W9-BPM-579

TO: Rev. Ben

From: Holly Erin Hafford

Treasures from Heaven

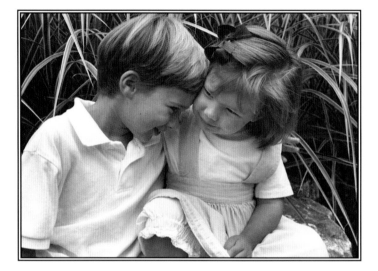

Treasures from Heaven

The Gift of Children

Sister Carol Ann Nawracaj, O.S.F.
Photographs by Monica Rich Kosann

PENGUIN
STUDIO

*This book is dedicated to
the children.*

PENGUIN STUDIO
Published by the Penguin Group
Penguin Books USA Inc., 375 Hudson Street,
New York, New York 10014, U.S.A.
Penguin Books Ltd, 27 Wrights Lane,
London W8 5TZ, England
Penguin Books Australia Ltd, Ringwood,
Victoria, Australia
Penguin Books Canada Ltd, 10 Alcorn Avenue,
Toronto, Ontario, Canada M4V 3B2
Penguin Books (N.Z.) Ltd, 182–190 Wairau Road,
Auckland 10, New Zealand

Penguin Books Ltd, Registered Offices:
Harmondsworth, Middlesex, England

First published in 1997 by Penguin Studio,
an imprint of Penguin Books USA Inc.

1 3 5 7 9 10 8 6 4 2

Text copyright © Carol Ann Nawracaj, 1997
Photographs copyright © Monica Rich Kosann, 1997
All rights reserved
CIP data available
ISBN 0-670-87289-X
Printed in Great Britain
Set in Weiss
Designed by Virginia Norey

Without limiting the rights under copyright
reserved above, no part of this publication
may be reproduced, stored in or introduced into
a retrieval system, or transmitted, in any form or by
any means (electronic, mechanical, photo-copying,
recording or otherwise), without the prior written
permission of both the copyright owner and
the above publisher of this book.

Acknowledgments

We would like to thank the many people who helped make this book a reality. Our deepest appreciation goes to Michael Fragnito, our publisher, for his personal interest, generous counsel, and enduring belief in this project. We extend our gratitude to Sarah Scheffel, our editor, for her patience, prodding, and invaluable guidance, and to Joel Fishman, our agent, for getting this book off the ground and sharing his engaging sense of humor and encouragement along the way. Special thanks to Sister Patrice Marie Klausing and Howard Kaplan for their insight and skill with words, and to Virginia Norey, Jaye Zimet, and Alix MacGowan, for their creativity and hard work.

—Sister Carol Ann Nawracaj and Monica Rich Kosann

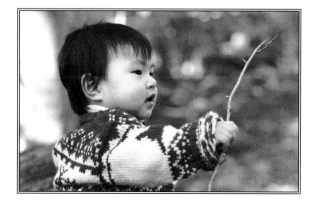

I am ever grateful for God's grace and His many gifts to me, especially for my parents, who gave me life, and for my family, which brings me so much love and joy. I am deeply grateful to the members of my Bernardine Franciscan community for their affirmation, advice, and understanding during this project, and to my good friends and colleagues who invariably inspired and encouraged me. My special thanks is offered to the children who influenced this writing and my life. Finally, I want to express my profound gratitude to my friend Monica Rich Kosann for initiating this book, and for her ongoing enthusiasm and dedication.

—*Sister Carol Ann Nawracaj*

I would like to thank all the beautiful children whose magic never fails to inspire me, and their families for their enthusiasm for this project. I am ever grateful to my parents and family, whose love and inspiration are constant. Special thanks to my friends who have always encouraged me. I must thank Sister Carol Ann, who whole-heartedly dove into this project with me and always believed. I enjoy our special friendship. And most important, thanks to my husband, whose devotion and hard work helped make this book a reality. Finally, I want to dedicate this book to my children, who always remind me of the truly important things in life.

—*Monica Rich Kosann*

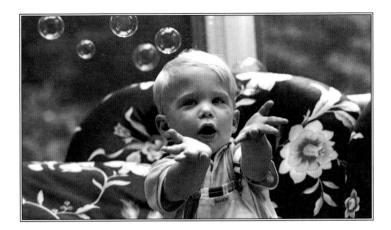

Contents

Introduction

Each morning, the children in our school gather in a circle to talk about what's on their minds. Often I learn more from the children than I do from the morning news. In the middle of the circle a candle burns. We focus on the light, and one by one the children speak. It begins with current events: one student might mention the children in Bosnia or Oklahoma City or the victims of a natural disaster or some other human-made tragedy. Then another child might talk about what's going on in his or her own home—Dad leaving on a business trip, an aunt expecting a baby, an older sibling going off to college, or a new puppy. After everyone has had an opportunity to speak, we conclude by reciting one of the Psalms together. And throughout there's the light shining in the middle of the room, and a spark glowing within.

What about the children? I hear this question constantly, and it never fails to conjure up images of the innocence and joy of childhood, my own childhood in a wonderfully supportive family, children in our school from a great variety of backgrounds, and the children of the world who find themselves in increasingly unfriendly environments. I believe that every child is a miracle, born with the potential for greatness, whatever that may be. Perhaps it's nothing more than the ability to grow into a compassionate and loving human being. We hear so much about the inner child, but what about the outer child, yearning to thrive in a world that has changed so much from the world his or her parents grew up in. What about the children . . .

Children are a blessing. In my thirty years as an educator, countless children have touched my life in and out of the classroom. I hope that in some small way I have touched their lives as well. The students at Villa Maria Education Center come in all shapes, sizes, and colors, and with all sorts of experiences, talents, and dreams. We're like every other school, but our children have special needs. Although some label them learning disabled, they've shown me that they're bright kids who learn differently. Over the past twenty-five years working with these special children, I've learned to teach them not only basic academic skills, but also how to feel good about themselves and to look for good in others. A recent letter from a student whom I taught twenty years ago concluded, "And I thank you, teacher, for teaching me more than reading, writing, and arithmetic. You taught me about life."

I've shared my students' joys at graduations, weddings, and the christenings of their children. I've also felt their sorrows at trials, in prisons, intensive care units, and funeral homes. We're all defined by dark moments as well as by the bright—one must learn the secret of turning up the wattage whenever necessary.

The bottom line, I think, is love: unconditional love. My parents offered it to me in handfuls. Mom and Dad were childhood sweethearts who married when Dad came home on a three-day furlough. Both were spiritual people who instilled their values in all four of their children. The love my parents gave me is the love I give back to the world. In all that I do, I have this incredibly powerful foundation of love on which to stand.

If a person's perception and memories of childhood color all of life, then my life is definitely a rainbow. My Mom shared her talents generously with those she loved. Every time she cooked a favorite recipe for the family or sewed a new dress in my favorite color or style, I was reassured by her love. My father nicknamed me Charlie, and wrote

me countless letters affirming how special I was to him. Even homework was fun when Dad was in charge. He'd bring home pieces of leftover floor tile from a carpentry job and write words on them, which we'd arrange into our own homemade sentences. He'd also read to us and deliberately make mistakes to see if we were paying attention. I'm sure these techniques led to my joy in learning and planted a desire deep within to teach.

At a young age, I felt a calling to be a teacher and a religious. I was taught by the Bernardine Franciscan Sisters and inspired by their community life of prayer, joy, simplicity, and peace. Over the past thirty years I've nurtured these Franciscan values that once attracted me and now permeate my life as I "journey in faith and joy, sister and servant to all."

I'm constantly learning from the children. When I lose track of what's important, I have to remember to look at life through their eyes. Children see things that we, as adults, overlook. And in this fast-paced, fax-it-to-me-now world of technology, a child's perspective is refreshing. I took the children on a ferry one day to show them the sights of Manhattan. With great enthusiasm and excitement I called their attention to the skyline, the Twin Towers, the Empire State Building. Do you know what the children did? They found a small crack in the ferry from where they could watch the water under our feet and were mesmerized by the lapping of the waves.

"Look at the skyscrapers!" I said.

"Look at the water we found," they replied.

And they were right. It takes a child to see the world from the bottom up. It takes a child to see how the smallest, most everyday things are filled with wonder.

Maybe that's one of the true gifts of magic—to present an alternative way of seeing. As a child growing up in New Jersey, I found magic a fascinating hobby and enjoyed making people laugh. Back

then, whenever I'd announce that I was going to perform a new trick, I had the uncanny talent of making my audience disappear! Today, I'm a member of the Society of American Magicians, and my illusions and patter have improved. But my best magic is reserved for my students. I use magic—**M**otivate **A**nd **G**ive **I**nspiration to **C**hildren—as an educational tool. This magic is not about making things disappear, but about the appearance of knowledge.

Both children and adults need creative, positive motivation. I discover this fact anew each time I address a group, whether it be my students, their parents, other educators, even a football team. As an honorary assistant coach of the New York Giants, I've learned that both children and adults respond to affirmation. I've known the Giants since 1974, when I was at Fairfield University studying for my master's degree in special education and the team was in training. In 1981, Ray Perkins, then head coach of the Giants, gave me my title and frequently invited me to give motivational presentations at team meetings and training camp. A 265-pound linebacker once wrote, "Sister, thanks for caring and believing in us." This taught me that regardless of age or occupation, the human person needs both a reason for trying and the encouragement to continue.

My reason for writing this book is the children. I firmly believe that each person deserves the opportunity to reach his or her full potential. The spirit within a single child is reason enough for spending one's lifetime in service of children. To see the joy on a child's face when he or she finally breaks the code and can read or learns a strategy for memorizing the multiplication facts is one of my greatest rewards. At every open house for our school, I perform an illusion for the parents of incoming students. I take a piece of paper containing the word "disabled," tear it, and fold it into a wad. When I open the wad, the paper is restored and now spells the phrase "is able," because every child that attends our school "is able" to learn if taught to his or

her strengths. When a child isn't learning the way we're teaching, I always encourage the teachers to teach the way the child can learn.

"Children are a gift from the Lord; the fruit of the womb a blessing" (Psalm 127 : 3). These words of Scripture speak not only to parents but to all society. Children are indeed a gift, and all of our endeavors must strive to reflect this truth. The world we adults fashion has a tremendous impact on children. What we believe, what we accept, what we foster and promote must be scrutinized for the effect it has on the future—our children.

When Monica Rich Kosann asked to photograph our students for *Family Circle* magazine, it was the beginning of a special friendship, and more. Monica has a unique artistic eye and a wonderful, generous vision. As the mother of two children, she knows firsthand about the richness of a child's daily world. Put a child in the garden, and she becomes a flower. A child in its mother's arms is a timeless symbol of hope. Her photographs are alive in the sense that she captures a child expressing who he is, naturally, without posing. She sounds very much like an educator when she talks about the importance of light in her work. Monica says she uses it "to express what is within the child as well as without. My photography captures the innocence of childhood in an age when daily events and popular culture erode the boundaries of a child's innocence."

As time went on, Monica and I met regularly, getting to know each other while sharing our differences but also our similarities. As we built our relationship, we found we shared a concern about children in the community in which we live and in the larger community of the world. We came to realize that we all have a mandate to care for the children because when we neglect and abuse our children, we neglect and abuse our future. Like so many others, we were shaking our heads in frustration and bewilderment, longing to recapture a simpler time, when the only thing children rushed home to turn on was their

imagination. We came to realize that we all have a mandate to care for the children; all of us—not just parents and teachers—are responsible for the well-being and safety of our children. Gradually, Monica and I decided to take the challenge, to take a stand against the negativity and violence in our world, and offer our collaborative answer to the question "What about the children?"

We decided on a book combining inspirational quotations from the Hebrew and Christian Scriptures with the medium of black-and-white photographs to counteract a culture of violence, a society growing numb to human loss and suffering. *Treasures from Heaven* is that book, a celebration of childhood innocence, the purest reminder of what is often lost in our daily lives. Children, through their presence, are a treasure from heaven, as are the selected biblical passages that serve as inspiration. Certain words accompany us from the time we are very small all the way through adulthood. For me, the words of Scripture have always been present, words that have made a difference in every facet of my daily life and work. Words that bring consolation, peace, serenity, joy, and energy. Coupled with Monica's photographs, these familiar words have taken on new meaning and power.

The images and messages set forth in this book remind me that we need to look at where we're headed, and stop worrying about how fast we'll get there. Our future and the future of our children are in our hands. Yet it is one of the paradoxes of life that although we as adults make the decisions that affect the lives of countless children, we all benefit when adults take the time to reflect on the lessons children teach us. Scripture reminds us that there is much to learn, for "what God has hidden from the learned and the clever He has revealed to the merest children" (Matthew 11 : 25). If our book could inspire each adult to change the course of just one child's life, then maybe, just maybe, every child could grow up in a world of peace, laughter, wonderment, and love. It is their right; it is our responsibility.

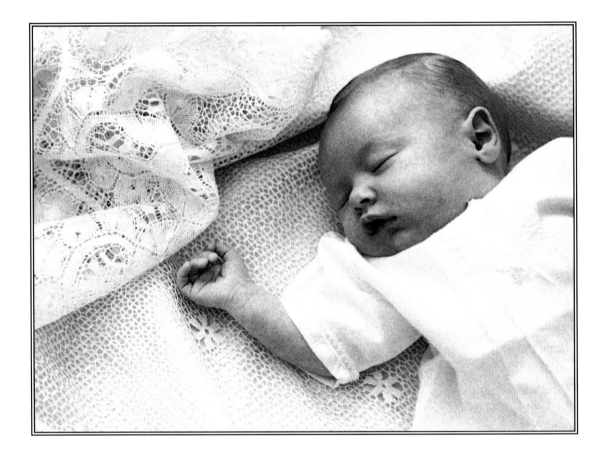

The
Gift of Life

Babies have an incredible power to evoke the strongest human emotions. In their helplessness and vulnerability, they touch what is deepest in the human heart. In the presence of a newborn, I am overwhelmed by the feeling that I am also in the presence of the sacred. What I am trying to express is perhaps best summed up in a conversation I had with a preschool sibling of one of our students about the birth of a new sister.

When I congratulated him and asked how he felt about the baby, he replied, "She's so small that I have to be real careful when I'm around her because I could accidentally hurt her. But I love to look at her and touch her, because she still has God's fingerprints on her."

She still has God's fingerprints on her. . . . Is this what even toddlers seem to understand? Have you ever watched the reaction of babies who are only a year or so old when they see a tiny infant? They often whisper "Baby" in an awed tone of voice; they inevitably want to touch and, more often than not, they do so with utmost gentleness.

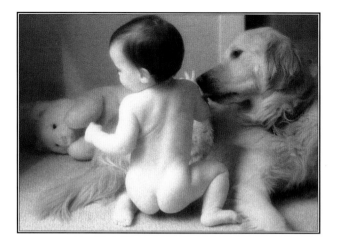

Babies are vulnerable, with few defenses, and totally dependent on the goodwill of caring adults. They have no worldly resources for imposing control, yet they compel us to provide for all their needs. In their weakness, they rely upon our strength and willingness to do everything possible to help them grow. They touch us at the deepest center of our being, and we respond to them. Sometimes our capacity to love them surprises us. A new mother was sharing with me her experiences of bonding with the child in her womb, of loving this child yet-to-be-born. In a voice filled with awe, she confided, "But now that he is born and I see my child and hold him and nurse him, I love him even more. I didn't think it was possible, but it is."

These smallest of children are ever-constant reminders of hope, of continuity, of the meaning and purpose of life itself. A mother took her six-month-old child to a nursing home to visit the baby's great-aunt. As she carried the baby past a very old woman sitting in a wheelchair, the woman smiled, stroked the baby's hand, and clearly said, "Baby." The nurses were amazed. The woman had long since stopped responding to her environment and had not spoken in

months. For this woman, a baby's being penetrated emotional barriers and gave her a sense of connection with the outside world. For the toddler mentioned previously, a baby elicited protective feelings and a sense of connection with someone even more vulnerable than himself. This compelling power inherent in new life can have a profound impact on our lives. It demands that we tap into our deepest inner reserves and find the capacity to nurture, to give fully of ourselves.

In our school, we look for and enjoy occasions to celebrate life, provide recognition, and affirm others. Near the main entrance stands a display blackboard that heralds the birthdays of faculty and students, announces births of siblings, and acknowledges the presence of visitors. These messages provide constant reminders about the value of life. No matter what the age, everyone likes to be treated as someone unique, someone special. We try to teach our students to recognize and appreciate the strength and fragility inherent in life at every stage of development and that throughout our lives we carry God's touch.

Innocence, freshness, and softness permeate an infant's whole being. I sometimes wonder who is being comforted when I hold a little one or cradle him or her in my arms. I think this innocence is part of the magic that babies bring to our world. Their very newness makes us yearn to be reborn, to heal the wounds that we have accrued in the course of our lifetime. Their innocence seeps into our souls, giving rise to the desire to be at peace with all. We imply all of this when we say that he or she is "sleeping like a baby." As I look at these photographs of sleeping infants, I see in them a reason to hope, to love, and to protect. I see contentment, peace, trust. I see the fingerprints of God.

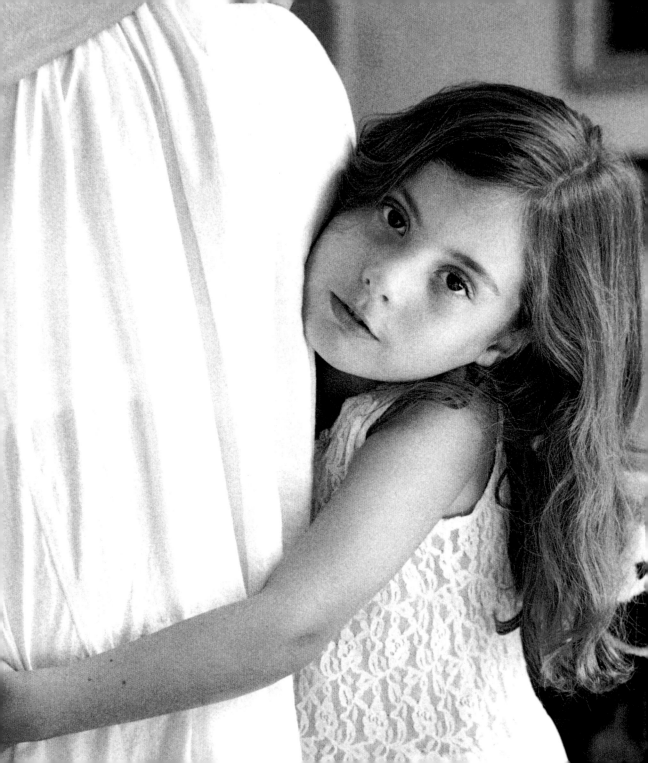

Before you were born,
I knew you.

—*Jeremiah* 1 : 5

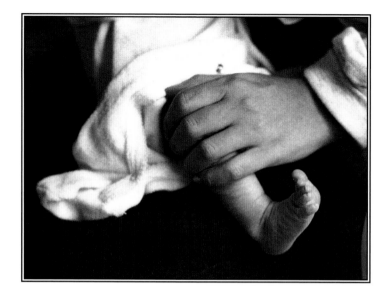

※

※ Truly you have formed my inmost being: you knit me in
my mother's womb.

—*Psalm 139 : 13*

And when I was born, I began to breathe the common air,
and fell upon the kindred earth; my first sound was a cry,
as is true of all. —*Wisdom 7 : 3*

I have called you by name, now you belong to me.

—*Isaiah* 43 : 1

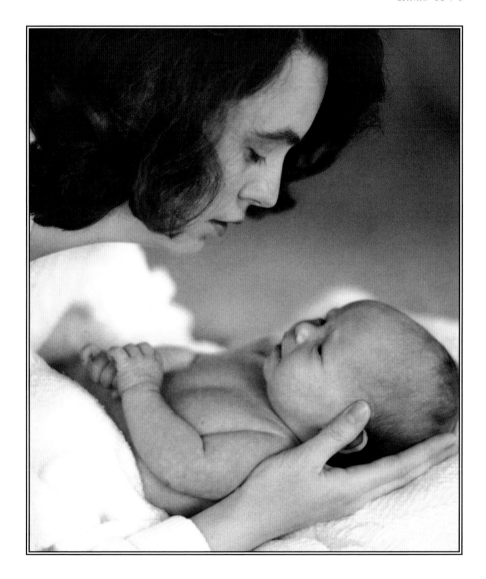

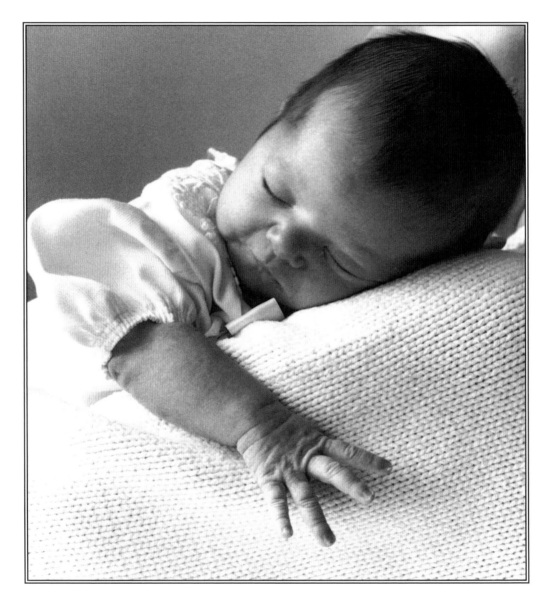

You will be like a child that is nursed by its mother; carried in her arms and treated with love.

—Isaiah 66 : 12

The Lord your God is with you. . . . He will quiet you with His love.

—Zephaniah 3 : 17

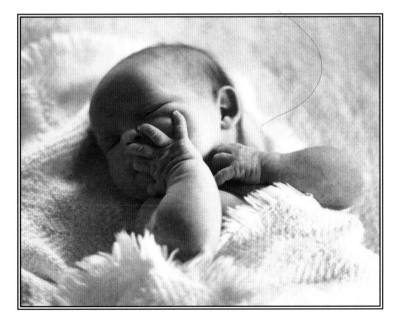

9

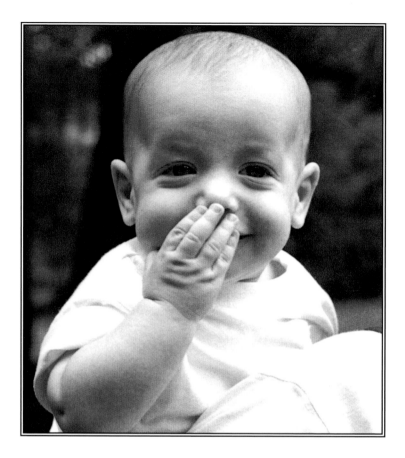

The child grew and became strong . . . and
the favor of God was upon him.

—*Luke* 2 : 40

The spirit of God has made me, and the breath of the Almighty gives me life.

—*Job* 33 : 4

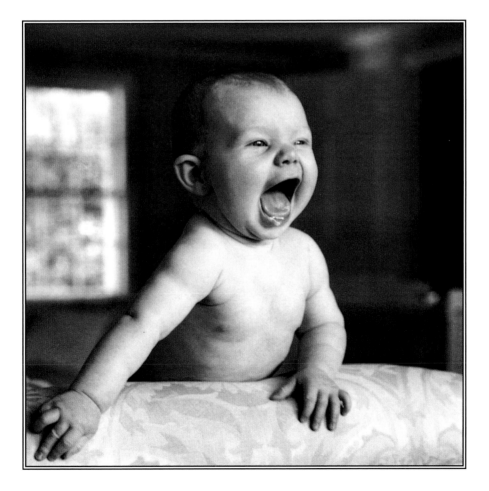

Love is very patient and kind, never jealous or envious, never boastful or proud, never haughty or selfish or rude. Love does not demand its own way. It does not hold grudges and will hardly ever notice when others do it wrong. It is never glad about injustice, but rejoices whenever truth wins out. . . .

All the special gifts and powers from God will someday come to an end, but love goes on forever. —*1 Corinthians 13 : 4–8*

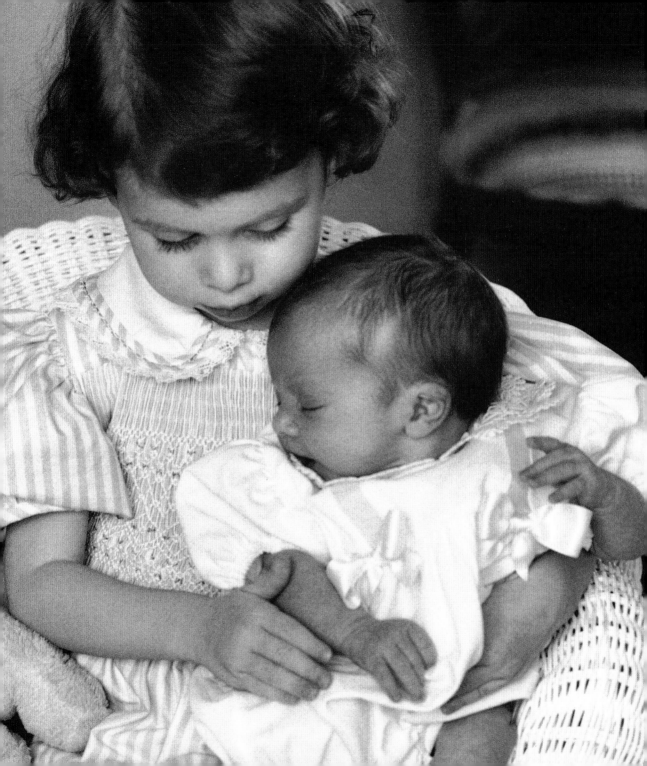

The
Gift of Trust

Trust is the foundation of human relationships. This trust is generated not only by spoken messages but also by a meaningful look, a touch, a hug, a kiss, lifting a child on your lap, holding his hand, or simply laying your hand on her shoulder. In the photograph of the mother cradling her infant against her face, I note the gentleness with which the child is held and see the unconditional love reflected in the mother's eyes. I can almost feel the baby's sense of well-being and contentment. Properly and lovingly nurtured, this bond of trust between parent and child begets a spirit of compassion and kindness and a sense of security that grace a lifetime.

We all need to know that we can depend on someone. This is especially true of children, who trust adults for their well-being. Their trust, however, evokes from us a responsibility. One doesn't plant a garden and sit back and watch it grow. The plants need patience, care, watering, and weeding. Children likewise need protection, shelter, clothing, nourishment, guidance, encouragement, and love. They need an environment where they are comfortable, are not afraid to

take risks, can develop self-confidence, are able to interact with others, and can enjoy life.

Children have faith and confidence that the adults in their lives care for them and will do what is in their best interests. Because an adult is often preconditioned to interpret certain behaviors in a particular way, a child can be stigmatized or lost. I remember the parents who brought their son to our school after various professionals had told them that their boy had little capacity to learn. These professionals recommended special schooling geared to basic life skills, but the parents disagreed with this diagnosis and promised each other that they would have their son evaluated one more time. After careful testing, it was determined that the boy was actually quite bright but needed help in compensating for his learning disabilities.

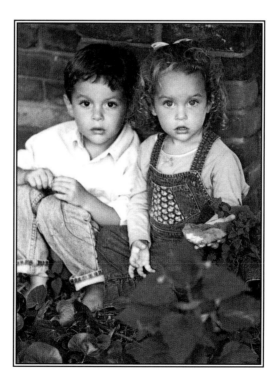

The parents did not give up on their son. Because they had faith in him and in our school's philosophy, he learned and blossomed. Interestingly, when he and the other graduates made plaques for their parents for Appreciation Night, he chose the word TRUST, while all his peers chose LOVE. In answer to my inquiry, he explained that trust was a quality stressed in his family. Not only did he have an enormous amount of trust in his parents, but they trusted him—that he would always live the integrity and values they instilled in him. That plaque still hangs in their family room. Almost fifteen years have passed. I participated in the young man's Eagle Scout award ceremony, attended his high school graduation, celebrated his college degree, and was present at his farewell party the day before he left for a tour of service in the Peace Corps.

I know my world would be a much better place if I let go of the fear that intrudes my life. The Scriptures tell us that "fear is useless; what is needed is trust" (Luke 8 : 50). What a difference it would make if I could respond with childlike trust to all people, to my environment, and to the circumstances of my daily life. Children trust so naturally and easily. Their response to life overflows with an eagerness to grasp each moment and to trust its goodness.

As adults, I think we come closest to understanding trust when we are recipients of another's trust. I can recall experiences of being trusted with someone's pain, embarrassment, doubt, fear, or need for forgiveness. At these times, I find myself not judgmental, but humbled and filled with compassion. Sometimes, the trust of other human beings feels like a very grave responsibility, but their willingness to trust us affirms their belief in us. It empowers us to reach beyond ourselves and our limits. I cannot help thinking—we have all been entrusted with the children. How will we choose to fulfill this sacred trust?

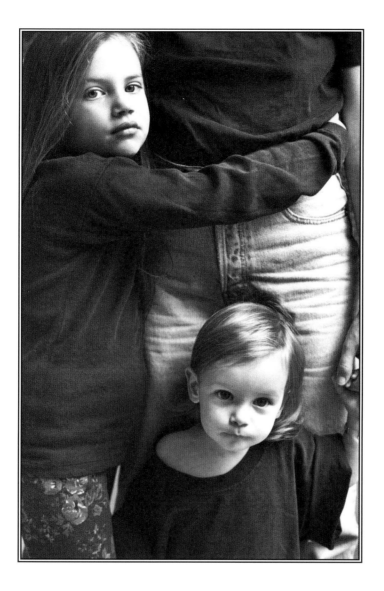

I am with you always, even
to the end of the world.

—*Matthew* 28 : 20

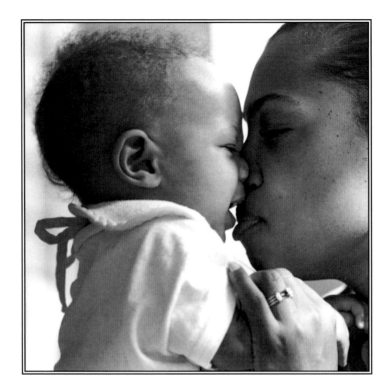

I drew him close to me with affection and love; picked him up and held him close to my cheek; I bent down to him, and fed him.

—*Hosea 11 : 4*

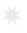

He will turn the hearts of parents to their children and the hearts of children to their parents. —*Malachi 4 : 6*

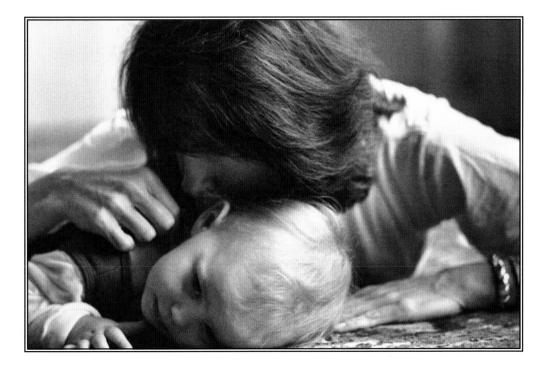

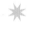

Don't be afraid, for
I am with you.

—*Isaiah* 43 : 5

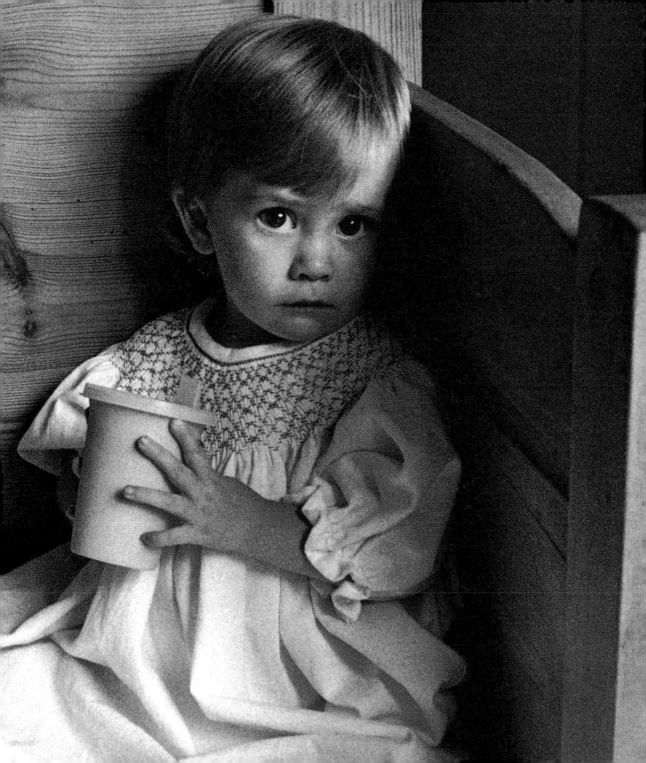

And you will have confidence, because there is hope; you will be protected and take your rest in safety. —*Job 11 : 18*

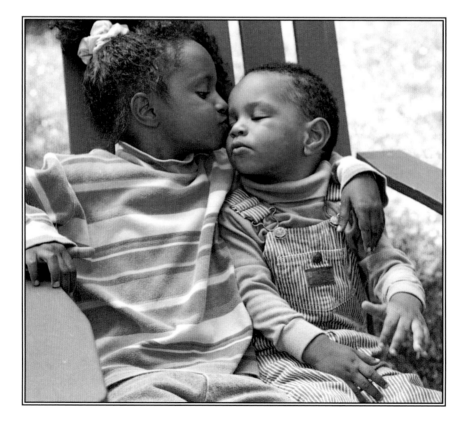

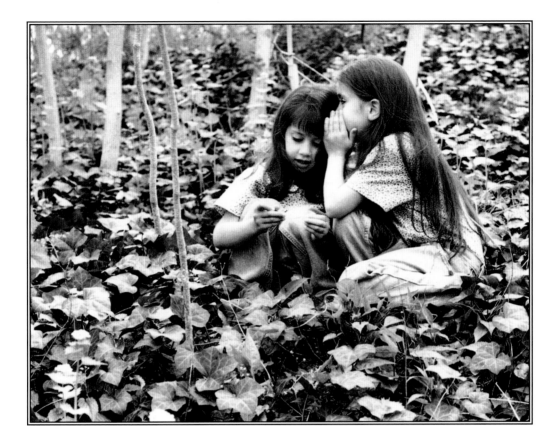

A trustworthy person keeps a secret.

—*Proverbs 11 : 13*

The Lord is my shepherd; I shall not want.
In verdant pastures He gives me repose.
 Beside restful waters He leads me; He refreshes my
 soul. He guides me in right paths for His name's sake.
Even though I walk in the dark valley I fear no evil;
 for You are at my side. With Your rod and Your staff
 that give me courage.

—Psalm 23 : 1—4

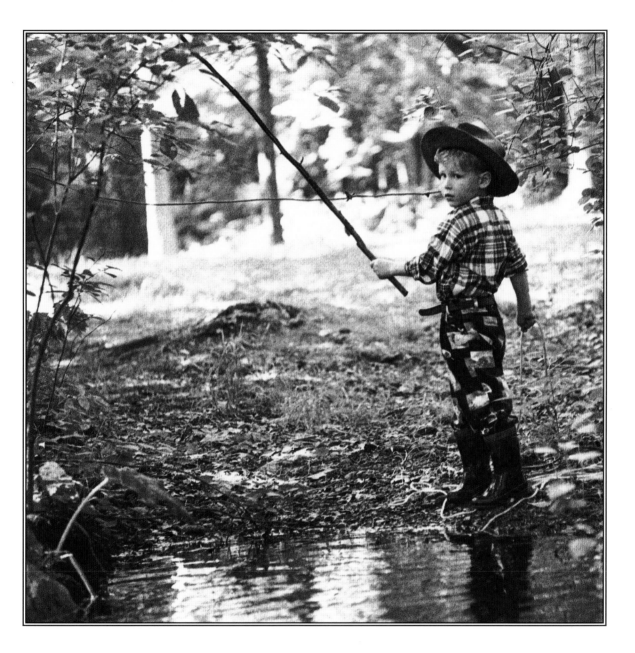

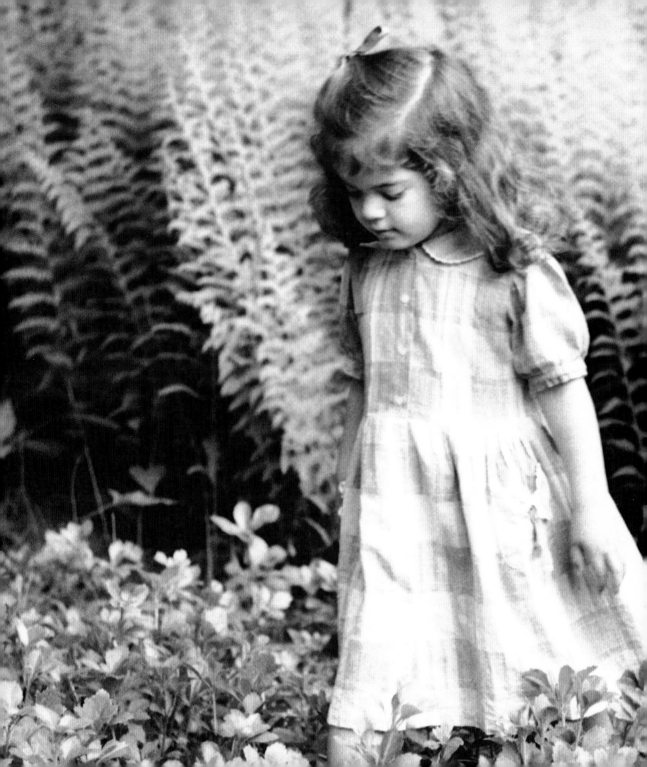

Can any of you by worrying add a moment to your lifespan? If even the smallest things are beyond your control, why are you anxious about the rest?
Notice how the flowers grow. They do not toil or spin. But I tell you, not even Solomon in all his splendor was dressed like one of them. If God so clothes the grass in the field that grows today and is thrown into the oven tomorrow, will He not much more provide for you? As for you, do not seek what you are to eat and what you are to drink, and do not worry anymore.

—Luke 12 : 25–28

Show me the path where I should go, point out the right road for me to walk. Lead me: teach me.

—*Psalm 25 : 4–5*

The Gift of

Wonder & Discovery

A child's world sparkles with promise and captures the imagination. Great and simple things fascinate the mind and call out to be studied and revered. From the child's perspective, nothing is too trivial, too unimportant. Everything has value and deserves the time bestowed upon it.

The children help me to observe my surroundings, to be aware of the wonders all around. Our playground equipment includes swing sets, a seesaw, a sliding board, tires for climbing, and a basketball hoop, but at one recess a group of children spent the entire time entranced by an inchworm on a twig. The children remind me to see God in a daisy or in a caterpillar. Often after recess, I return to my office clutching a bouquet of dandelions, violets, fall leaves, or pine cones—all gifts from students whose vision has enlightened me.

Even the littlest of children have something to teach us in this regard. I love to watch an infant staring at its hand or foot with tireless

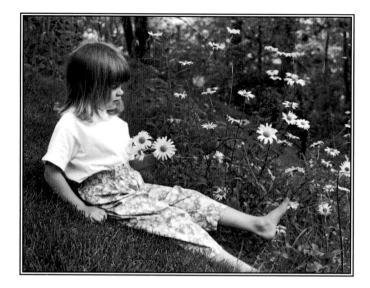

fascination. I delight with the toddler looking into a mirror and realizing for the first time whose face it is. The child's natural ability for contemplating his or her own body speaks a powerful message to me. I too need time to gaze upon myself and reflect on the deepest truths of my being.

Far too often life becomes frantic and frazzled. There is never enough time. Consequently, I find myself caught up in a never-ending circle of attending to multiple tasks at the same time, of having to make difficult decisions about how and where to spend my time. My body and my soul become weary with this constant juggling act. I cry out for time to nourish my spirit and my relationships.

I think that perhaps I need to examine my days, to create moments when I am free to enjoy what life offers to me in the present moment. I need to find time to nurture myself. I need to allow myself to experience and reflect on the opportunities for awe and delight that each day brings.

Both parenting and teaching offer adults the reward of participating in a child's joy when she or he makes some great discovery. Because I have worked with learning-disabled students for so many years, I am particularly touched when a child—often one who believes he or she cannot learn—breaks the language code and begins to read. The transformative power in this discovery is a miracle in itself. It restores self-esteem, builds confidence, and imparts an eagerness for learning that indicates the child's real potential. To provide such a moment for a child—to encourage and support the emerging gifts—may be the greatest blessing we bestow on our children.

In the following pictures, you will witness children absorbed in the beauty and intricacy of nature. They possess the ability to penetrate to the heart of things. In their seeing, they also display an innate reverence for what they behold. Notice the alert stillness of the boy standing before a giant spider web, the gentleness with which another holds a turtle. These children know and appreciate the beauty I so often fail to comprehend. They relate to what is simple and free—sun and clouds, moon and stars, water and snow, birds that fly and creatures that crawl, and green growing things. All of us would do well to follow the example of the children, for the earth abounds in beauty and sustains us all.

Someday soon I plan to give a four-year-old a disposable camera with the instruction to take pictures of "what you like." I suspect that the developed pictures will reveal a unique perspective that will challenge my vision, deepen my understanding, and call me to wonder anew. Indeed, "There is no way to comprehend the marvelous things the Lord has done. When we come to the end of that story, we have not even begun; we are simply at a loss for words" (Sirach 18 : 4–5).

Mysteries greater than these are still unknown; we know only a fraction of His works.

—*Sirach* 43 : 32

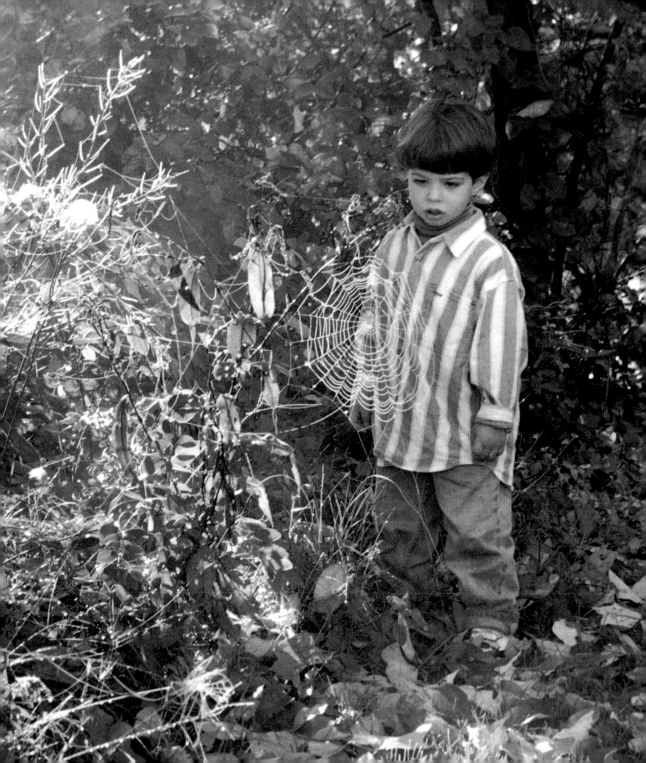

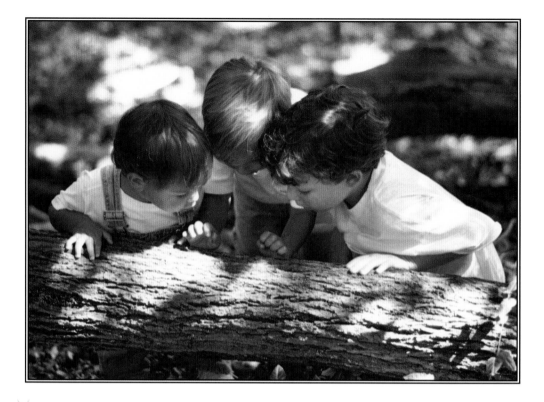

Great are the works of the Lord, studied by all who delight in them.
—*Psalm 111 : 2*

Praise Him for the growing fields, for they display His greatness. Let the trees of the forest rustle with praise.

<div style="text-align: right">—Psalm 96 : 12</div>

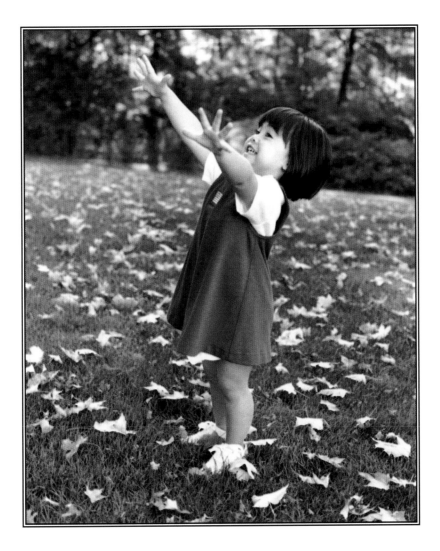

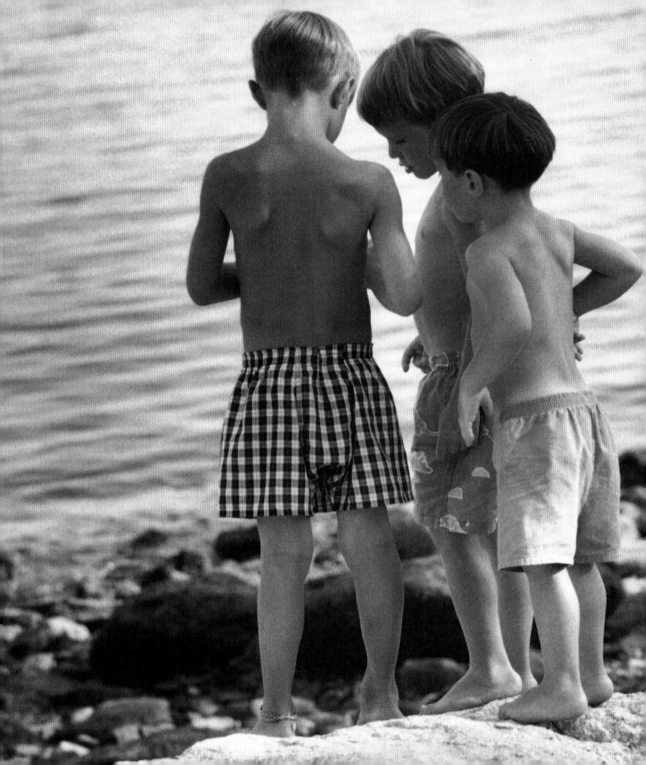

When I see Your heavens, the work of Your fingers,
the moon and stars that You set in place—
What are humans that You are mindful of them, mere
mortals that You care for them?
Yet You have made them little less than a god,
crowned them with glory and honor.
You have given them rule over the works of Your
hands, put all things at their feet:
All sheep and oxen, even the beasts of the field,
The birds of the air, the fish of the sea, and whatever
swims the paths of the seas.
O Lord, our Lord, how awesome is Your name
through all the earth! —Psalm 8 : 4–10

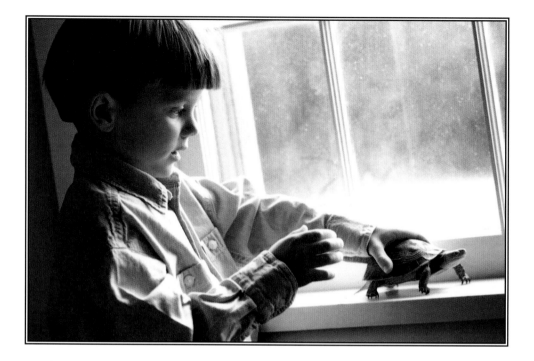

In His hand is the life of every creature and the breath of
all humankind. —*Job 12 : 10*

The earth belongs to God! Everything in the world is His!

—*Psalm 24 : 1*

I will meditate about Your glory, splendor, majesty and miracles.

—*Psalm 145 : 5*

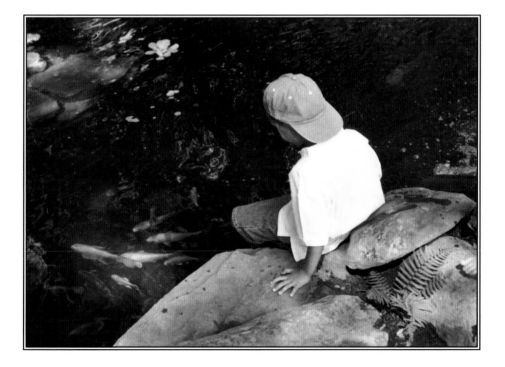

He reveals things that are deep and secret: He knows what is hidden in the darkness, and He Himself is surrounded by light.

—Daniel 2 : 22

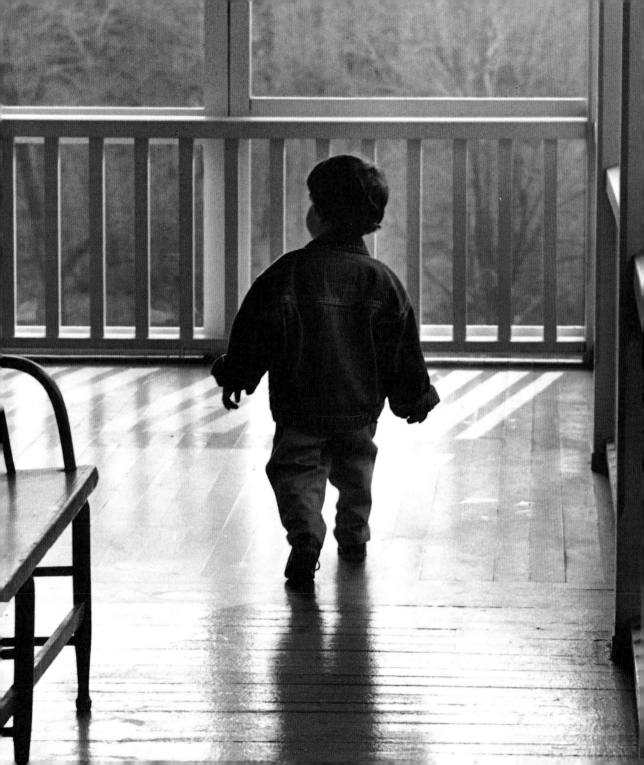

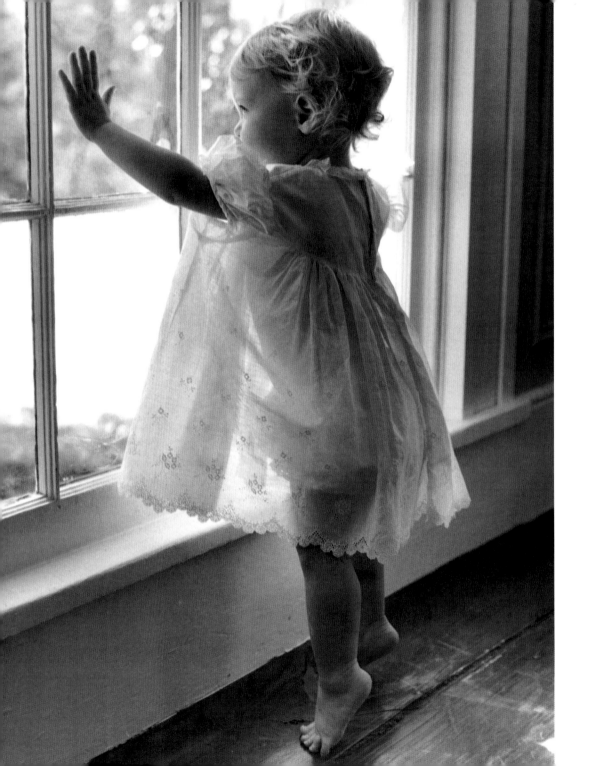

The Lord, who lives forever, created the whole universe, and He alone is just.

He has given no one enough power to describe what He has done, and no one can investigate it completely.

Who can measure His majestic power? Who can tell the whole story of His merciful actions?

We cannot add to them; we cannot subtract from them. There is no way to comprehend the marvelous things the Lord has done.

When we come to the end of that story, we have not even begun; we are simply at a loss for words.

—*Sirach* 18 : 1–5

The Gift of Happiness

The sound of children's laughter—is there any more heartwarming sound in the entire world? One afternoon I was walking down the corridor at school and heard giggling coming through one of the open doors. I stopped to see what was so funny and found the children enjoying a harmless April Fool's prank they had played on their teacher. "But," I said, "today is April 26. April Fool's Day is April 1." "Sister, you don't understand. We do this every day." Ah, the wisdom of the children! They understood that laughter brightened the day and refreshed the mind, body, and spirit.

At one time, the students moved to a separate building on our campus for physical education, music, art, and perception classes. The building came to be known as "Happiness Hall," because one child commented that all the happy and fun things took place there. The children recognized the value in taking time out from routines and serious business (for them, learning to read, write, and do math) to tap into other aspects of the self. Creativity, imagination, and self-expression enrich our lives and help to keep them in balance.

As I look at these photographs, words circle and dance in my mind—spontaneity, freedom, lack of inhibition, joy. The children are free to respond to their environments, to reveal their feelings and emotions. They do not measure and calculate every word and action for its appropriateness or acceptability. They are not inhibited by the expectations and constraints that society imposes on adults. There is an innate honesty to their emotions and relationships from which all of us could learn.

The Gospel tells us that "unless you become little children, you will never get into the Kingdom of Heaven" (Matthew 18 : 3). This doesn't mean that we should be childish, but childlike—in other words, possess the trusting nature of children, their carefree spirit, their simplicity, and their unconditional love. It's amazing how much time we spend on things that we say aren't important to us and how little time we spend on things that we say are important. As adults, we're so often caught up in the rapid technological advances of communication and in materialistic, cluttered lives. We need to take the time, make the time, and allow children to free us.

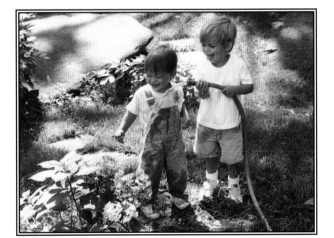

For me, some of the most memorable moments in my life have been times when I have allowed the child within the freedom to play and express herself. Once I was performing my favorite magic trick, in which I pretend to have blundered and burnt a spectator's hundred-dollar bill. I apologize that I didn't take time to practice the trick and offer solutions like taking the ashes to the bank. Ultimately, I restore the signed bill in a sealed envelope inside a zippered wallet. However, I was enjoying my mischief so much that I got carried away with my patter—the rapid-fire talk magicians use in their routines—and stalled a little too long before finally producing the bill. Some people in the audience were convinced that I actually had destroyed the kind gentleman's money and were taking up a collection to reimburse him. It's not just children who need to unwind and enjoy some joviality from time to time. . . .

Unfortunately, this does not happen often enough or without real effort. I don't know what it is I am afraid of. Maybe I'm afraid of losing my dignity or appearing foolish or incompetent. Yet I know that in the moments when it is appropriate to have the mind and heart of a child and when I give the child within free rein, something profound happens. I can't always articulate what change has occurred. I only know there is a sense of coming home to myself, of being set free.

Almost two hundred years ago, the poet William Wordsworth wrote,

> *Not in entire forgetfulness,*
> *And not in utter nakedness,*
> *But trailing clouds of glory do we come*
> *From God, who is our home. . . .*

Is this perhaps the source of children's happiness and laughter: that the trailing clouds of glory still cling untarnished to their spirits?

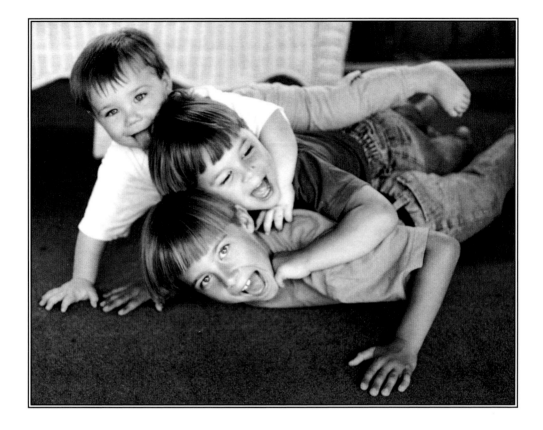

Be happy with those who are happy.

—*Romans 12 : 15*

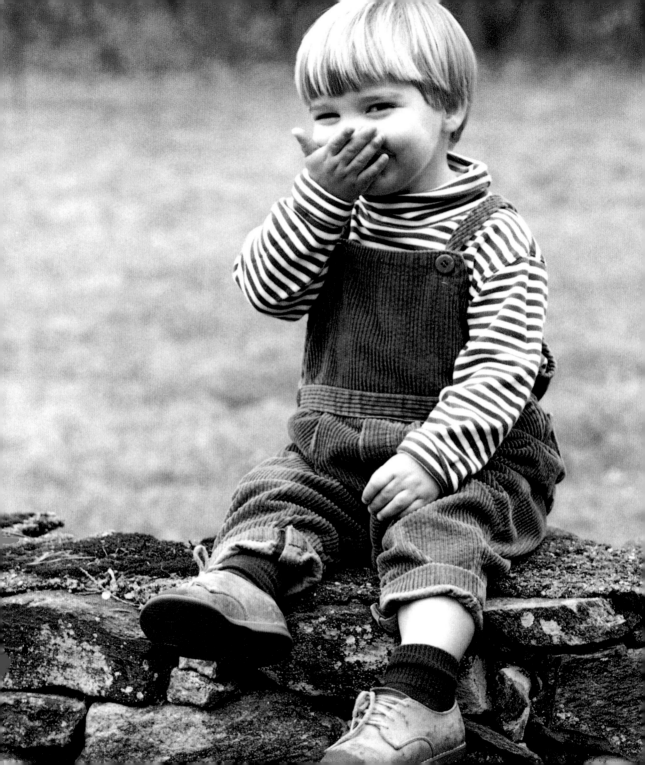

Fill us each morning with Your constant love, so that we may sing and be glad all our life. —*Psalm 90 : 14*

Then our mouth was filled with laughter, and our tongue with rejoicing. —*Psalm 126 : 2*

Their faces will shine like the sun, and they are to be like the light of the stars that never die. —2 *Esdras* 7 : 97

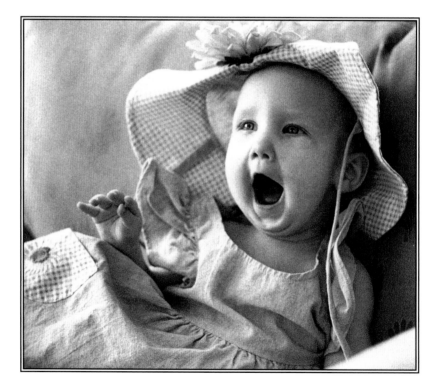

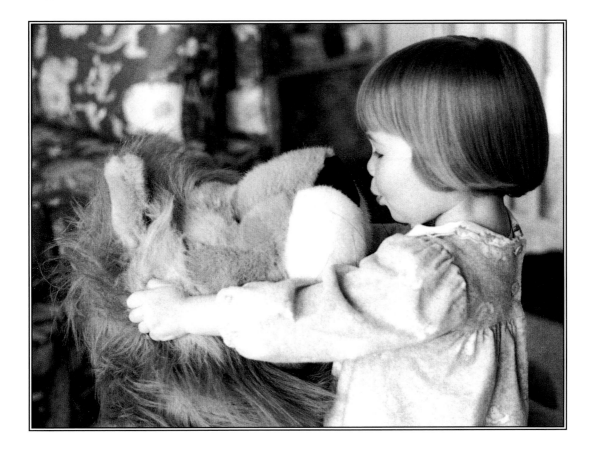

Be beautiful inside, in your hearts, with the lasting charm of a gentle and quiet spirit which is so precious to God.

—1 Peter 3 : 4

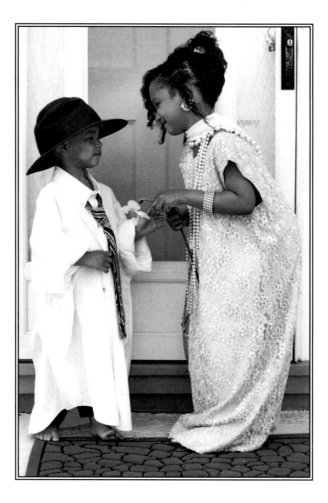

Young people, enjoy your youth. Be happy while you are still young. Do what you want to do, and follow your heart's desire. . . . Don't let anything worry you or cause you pain.

—*Ecclesiastes 11 : 9—10*

God loves a cheerful giver.

—*2 Corinthians 9 : 7*

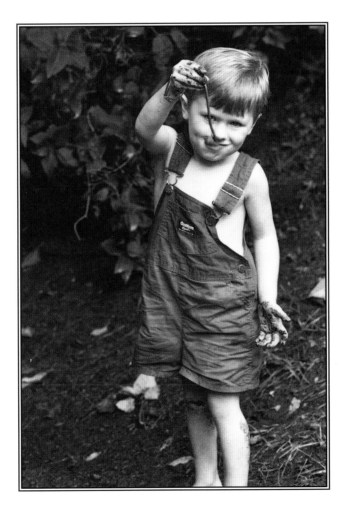

Rejoice in the day and leap for joy.

—*Luke* 6 : 23

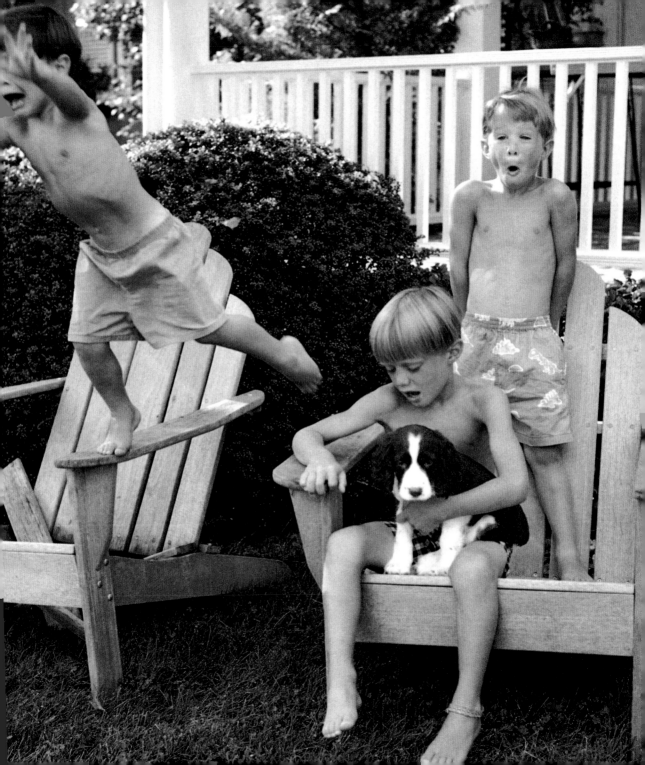

The Gift of
Love & Friendship

Human beings are not created to live in isolation. Children in-
stinctively know this. From a very young age, children of all cultures
actively seek playmates. The bonds that are forged between children
can last a lifetime and be a source of strength, comfort, and wisdom.

As a child explores his or her world, the presence and importance
of others gradually come to consciousness. Because very young chil-
dren have not been exposed to prejudice, they naturally reach out to
others. They more readily accept each other than we adults, no mat-
ter what the age, gender, race, religion, or nationality. Out on our
playground, the girls join the boys for a game of soccer, the older stu-
dents are pushing the younger ones on swings, and instead of worry-
ing whether anyone is playing with a handicapped child, I search to
find where they've wheeled him now.

As adults, it is our responsibility to help children learn about the
dangers of ignorance, intolerance, selfishness, prejudice, and injus-
tice. We must learn to teach by example the virtues of compassion
and love for others. Instead, all too quickly, children pick up adult bi-

ases. Our world would certainly be a more hospitable place if we took the time to meditate on and emulate the acceptance of others, which children often model.

Love implies a level of caring for and commitment to another that transcends personal needs. As children learn to treasure each other, they learn to value themselves. For to truly love another, one must also respect and value the self, and vice versa.

I have taught children who lived in elegant homes, children whose food was provided by public assistance, and children from every economic level between the two. The remarkable truth I have witnessed time and again is that children thrive on love. Children who are truly loved reveal that fact in a myriad of ways. Their eyes sparkle. They possess an enthusiasm and zest for life that is boundless. They respond to their environment. They very often perceive another's sadness or unhappiness. They possess different personalities, but the common denominator prevails: they walk in the knowledge of being loved. In turn, these children find it easy to love and trust others.

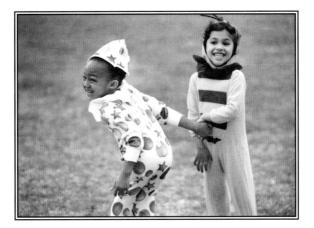

When I think of the friends who have enriched my life, I know myself to be blessed. I am thankful for the sisters in my community who continually affirm my projects. They celebrated and sent congratulations cards to me when the Giants won the Super Bowls XXI and XXV, and I felt their support and sympathy when they attended the wake and funeral of my dear Dad. When a close friend was faced with marital problems and a career change, I continued to write even though he did not respond. About a year later, when his situation improved, he wrote, "Thanks for being a friend when I couldn't be one in return." Friendship is about caring through the good times and through the bad.

The love and support of my family have tremendously influenced my own life and my capacity to love. My Mom replenishes the family unity with an outpouring of love and a deep abiding faith. My older brother and I had our sibling rivalry, but I knew that if anyone in our neighborhood dared tease me, my big brother was there to protect me, and he still freely shares with me his time and talents. My younger brother and I continue to inspire and encourage each other's creativity and dreams. My younger sister and I often have the uncanny ability to send people the same birthday, anniversary, or Christmas card even though we are in two different states, miles apart. She is constantly providing opportunities for our family to share traditions and milestones, and create more wonderful memories. As part of my grieving when my Dad died I wrote an article about him that appeared in the newspaper on Father's Day. A friend of mine read the tribute to my Dad, and with tears in his eyes, remarked, "I hope someday one of my daughters will write something like that about me."

There is always room for more love in the world, and we can all learn more about love from the children. How many times have I lis-

tened as the children in school inquire about the whereabouts or the health of a very sick classmate. How many times have I watched as a child found a way to restore friendship after a misunderstanding. How many times have I encouraged a child to say I'm sorry and felt his or her relief in making up.

What makes me so sure of the effect of love and friendship on a child's life? The testimony of the many children who have contacted me as adults speaks much more loudly and clearly than I can. Their memories of support and friendship warm my heart and invite me to remember. As I come to the end of this final chapter, I find myself echoing Anna's insight from *The King and I.* She sings, "by your pupils you'll be taught." I am grateful that I have had such wonderful teachers in my life.

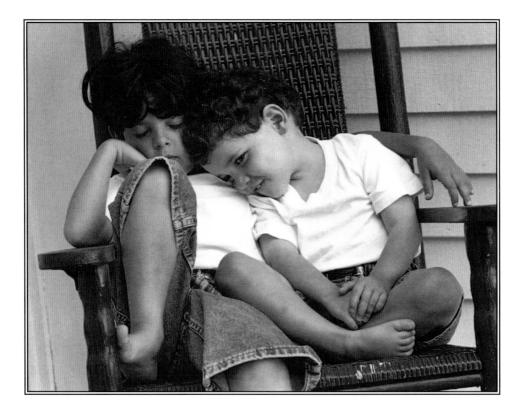

He who is a friend is always a friend.

—*Proverbs 17 : 17*

Two are better than one. . . .
If the one falls down, the
other can help him up.

<div align="right">—Ecclesiastes 4 : 9</div>

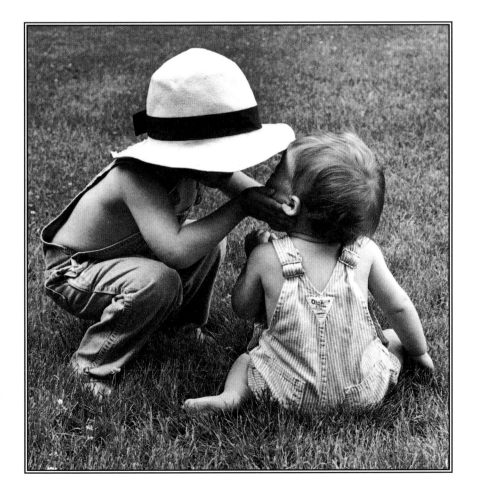

Do not ask me to abandon or forsake you! For wherever you go, I will go.

—*Ruth* 1 : 16

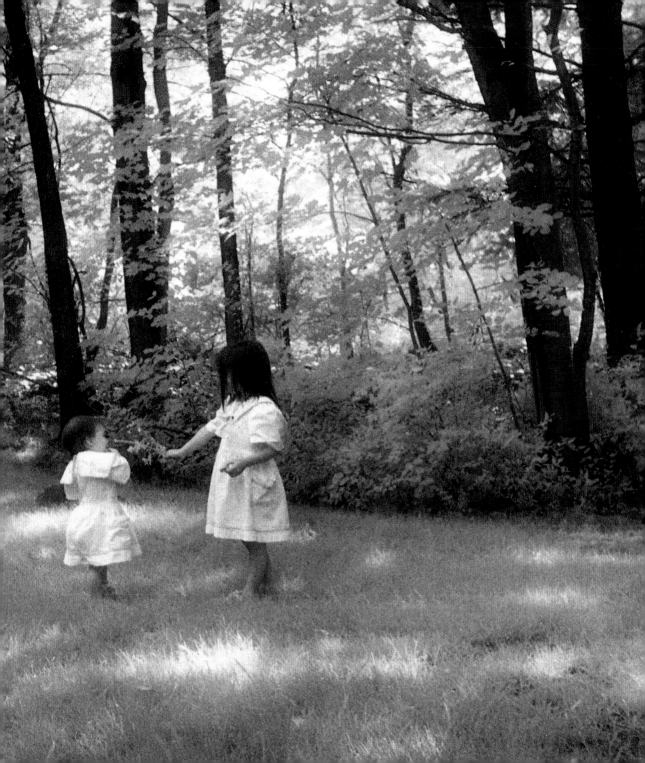

Let your acquaintances be many, but one in a thousand your confidant.

—*Sirach 6 : 6*

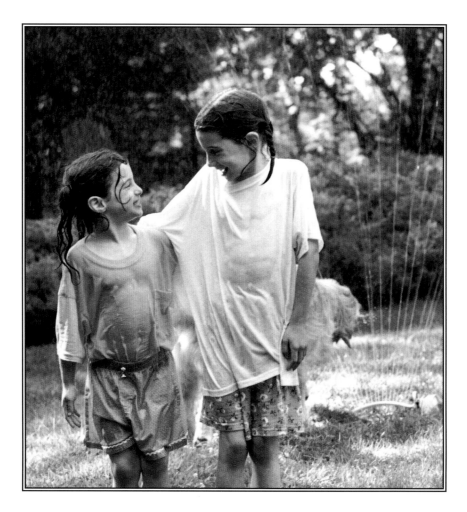

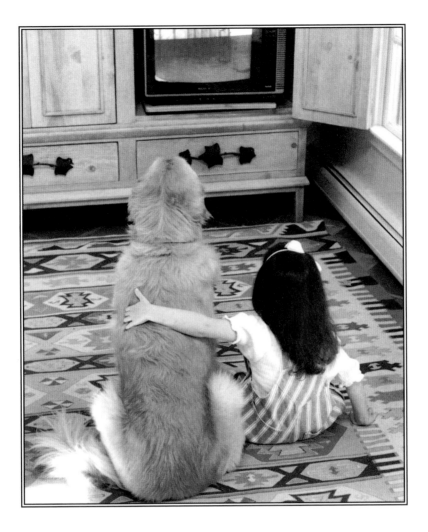

A faithful friend is a sturdy shelter; who finds one finds a treasure. —*Sirach 6 : 14–15*

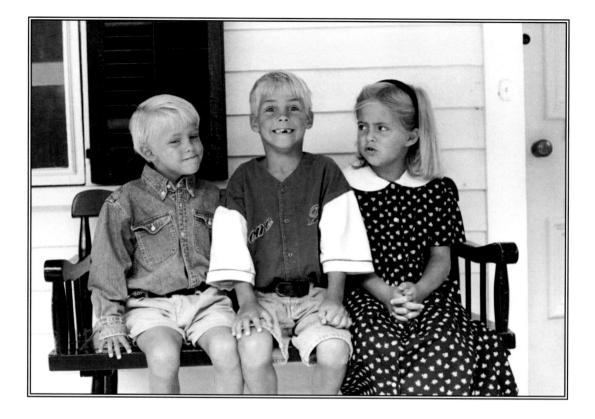

You should be like one big happy family, full of sympathy towards each other, loving one another with tender hearts and humble minds.

—*1 Peter* 3 : 8

Greet one another with a holy kiss.

—*2 Corinthians* 13 : 12

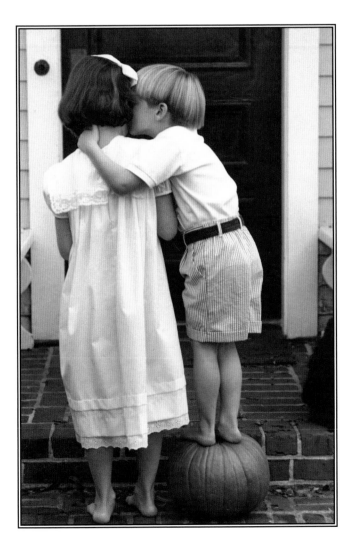

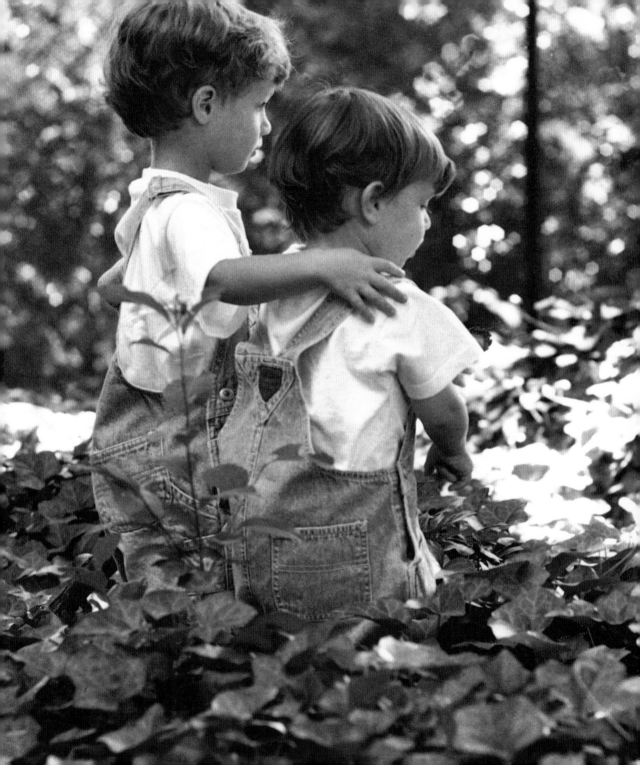

Love must be completely sincere. . . .
Love one another warmly as brothers
and be eager to show respect for one
another. —*Romans 12 : 9–10*

Be always humble, gentle, and patient. Show your love by being tolerant with one another. Do your best to preserve the unity which the Spirit gives by means of the peace that binds you together.

—*Ephesians 4 : 2—3*

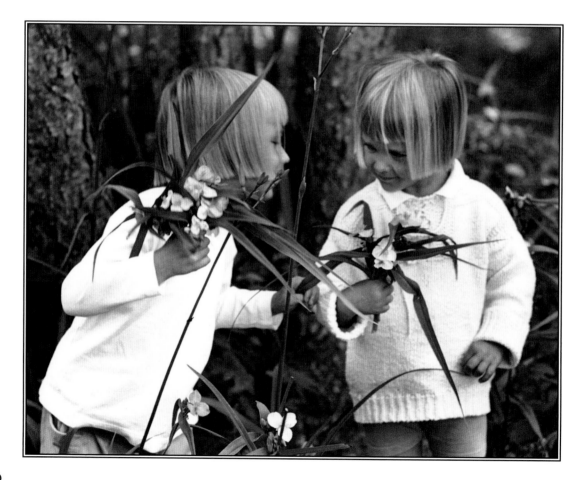

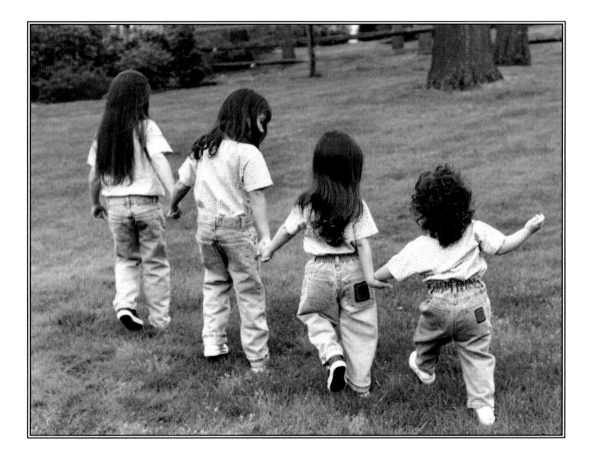

Most of all, let love guide your life. . . and stay together in perfect harmony. —*Colossians* 3 : 14

I give thanks to my God every time I think of you—which is constantly, in every prayer I utter.

—*Philippians* 1 : 3

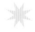

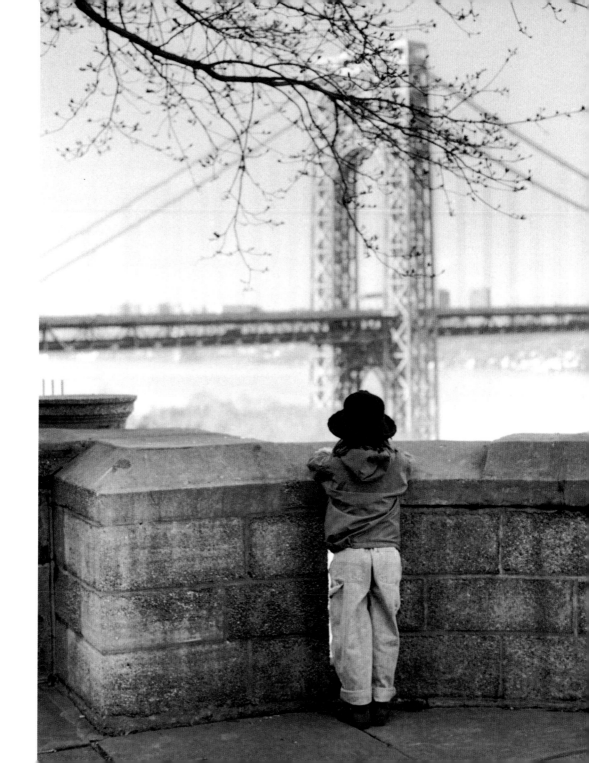

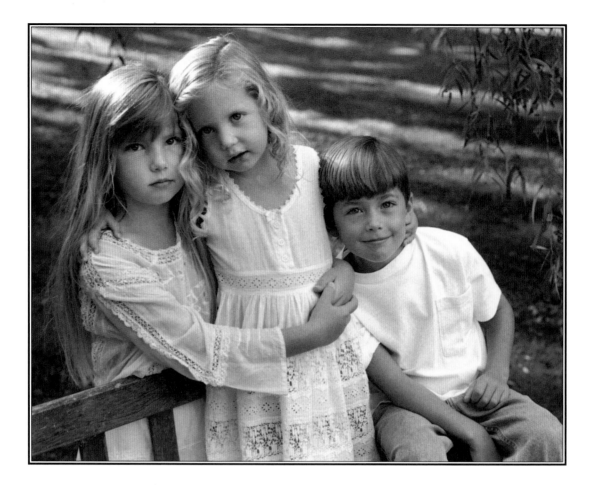

There are three things that remain—faith, hope, and love
—and the greatest of these is love. —*1 Corinthians 13:13*